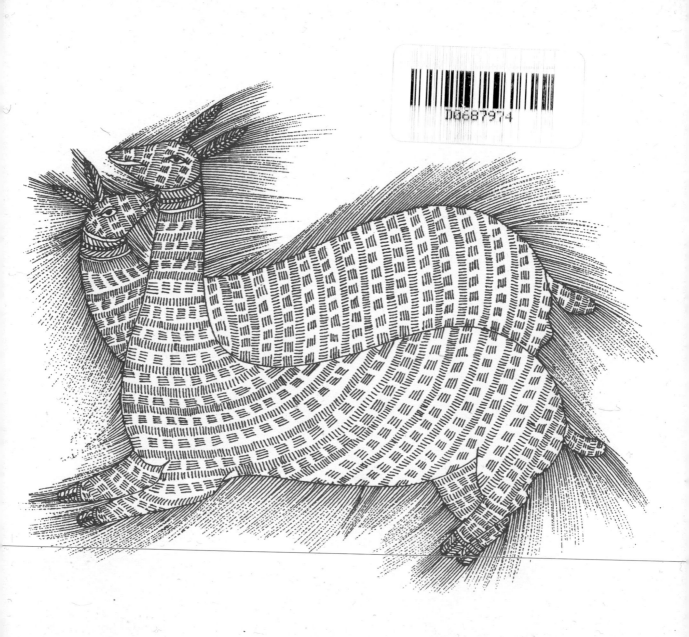

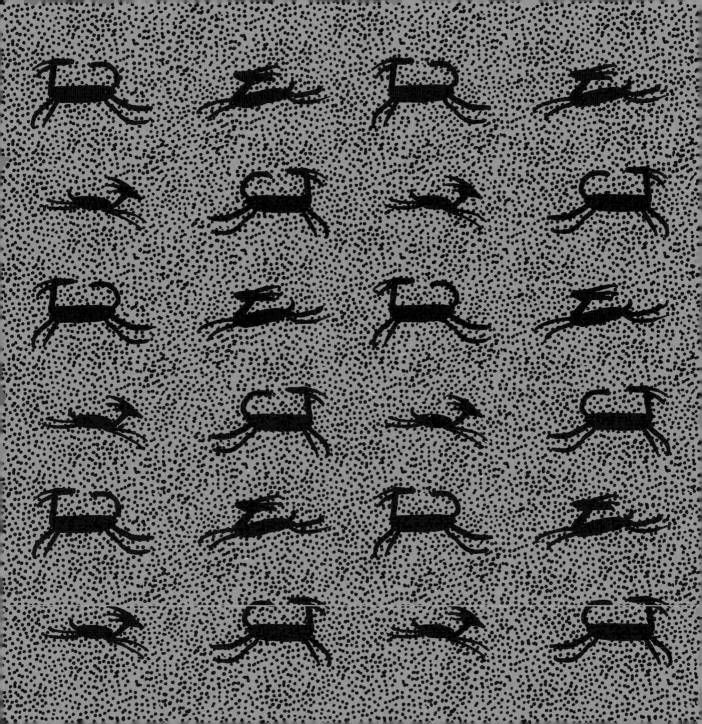

Acknowledgements

We would like to thank:

A. Gunasekaran for assisting with the artwork;

Madan Meena, Art Research Scholar, University of Rajasthan at Jaipur for permission to reproduce Meena art from his personal collection;

Bulu Imam for permission to reproduce Sohrai art from Hazaribagh / Jharkhand;

Nandkusiya Shyam for permission to reproduce art done by her late husband Jangarh Singh Shyam;

Tribes India (a unit of TRIFED), Crafts Museum, Dastkaar and Dilli Haat for their assistance with this project;

All the artists for generous permission to reproduce their work and for making this book possible.

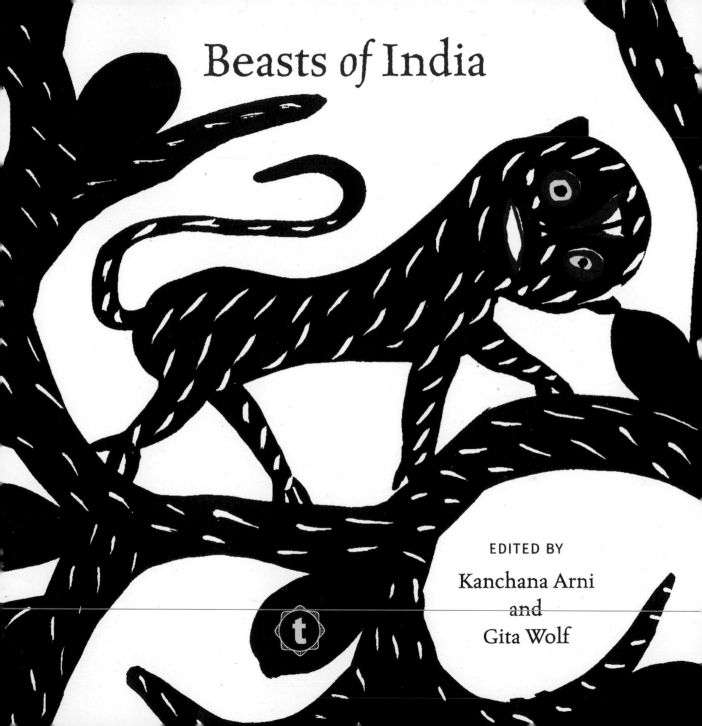

Beasts of India

EDITED BY

Kanchana Arni
and
Gita Wolf

TIGER

PITHORA

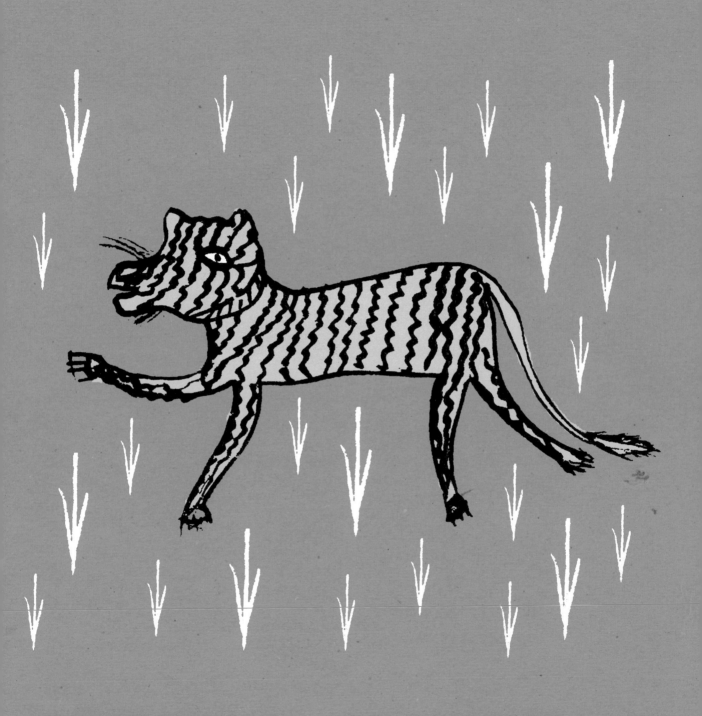

TIGERS

GOND

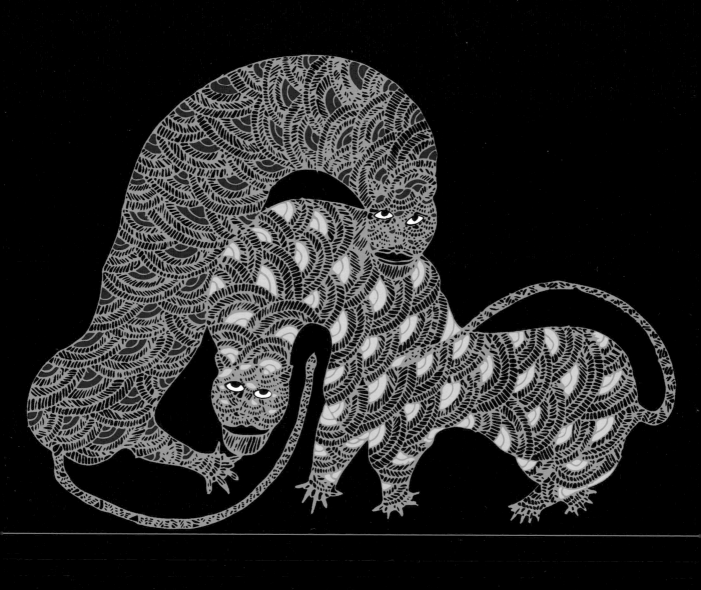

TIGER

PATACHITRA

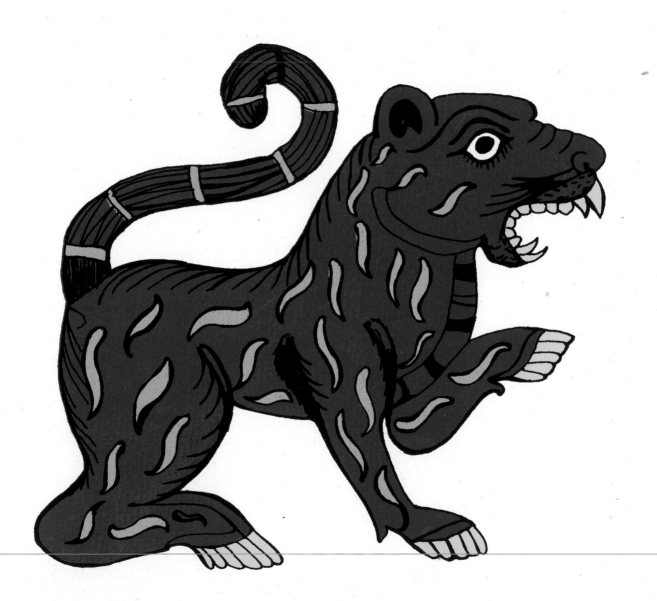

TIGER

SOHRAI

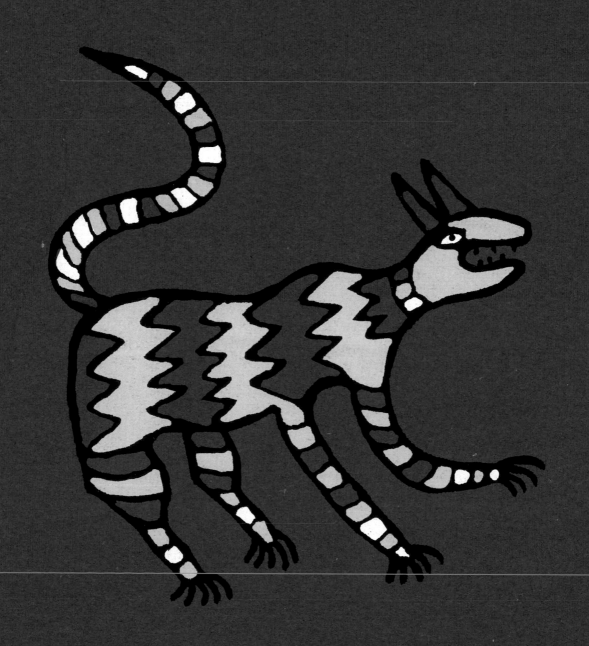

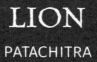

LION

PATACHITRA

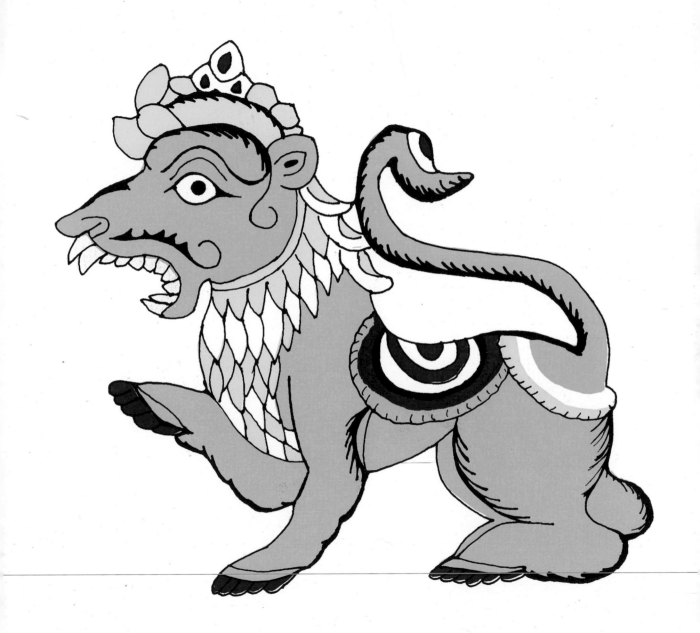

LION

MADHUBANI

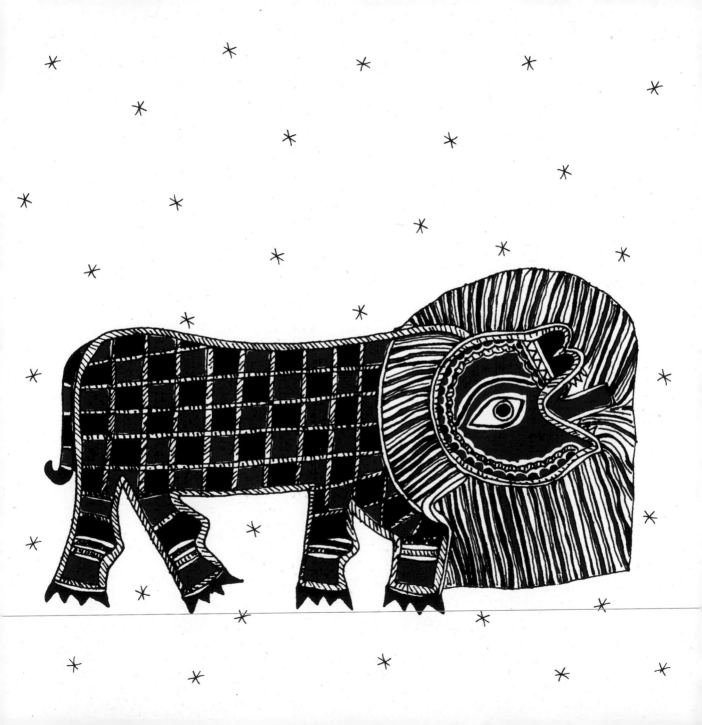

DEER

KALAMKARI

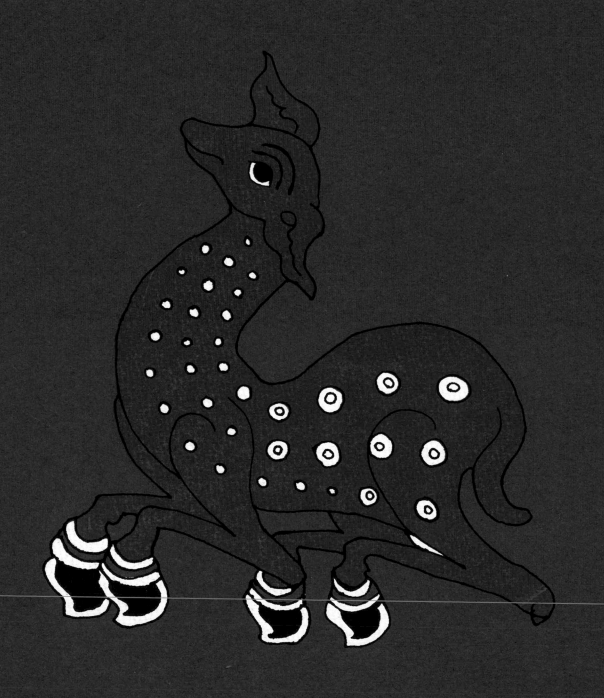

DEER

GOND

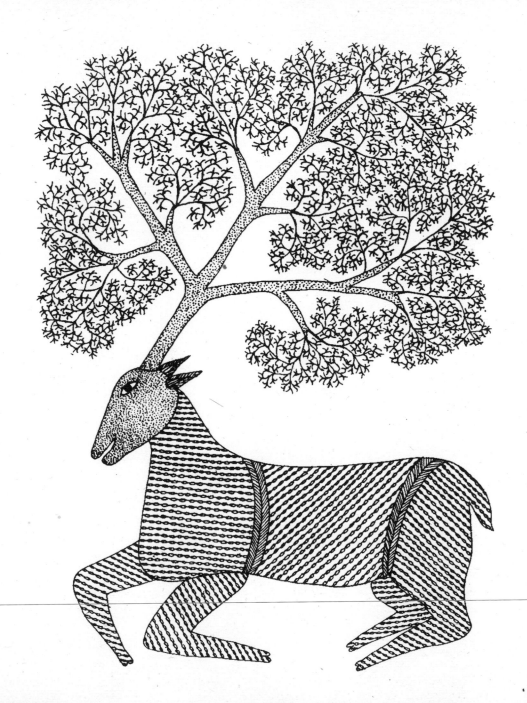

DEER

GOND

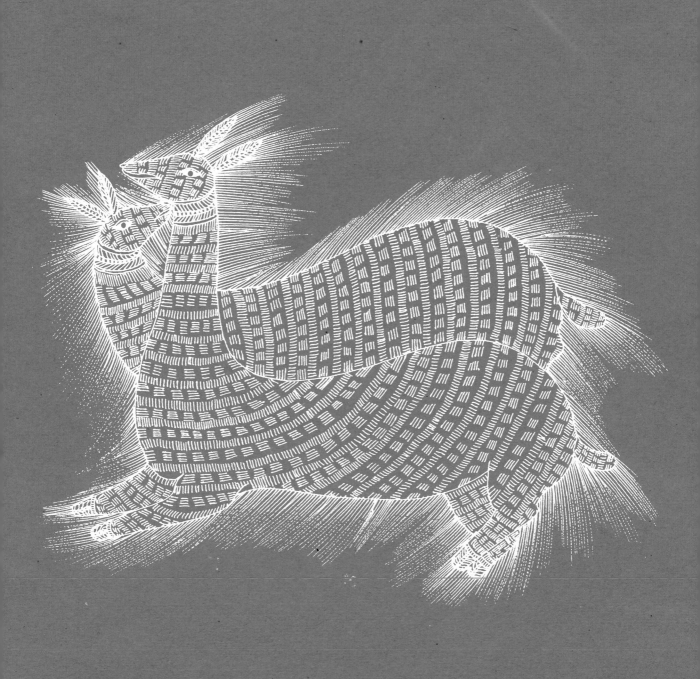

ANT-EATER

PITHORA

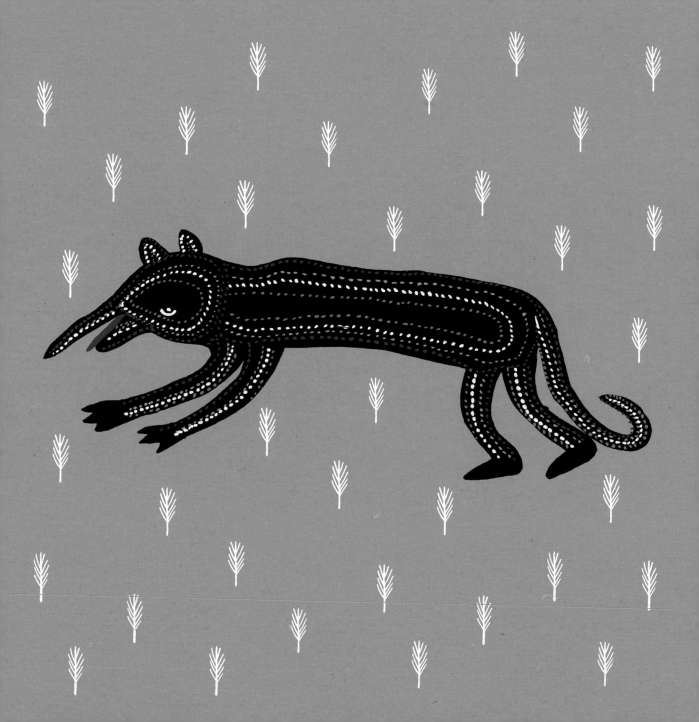

SNAKE

SOHRAI

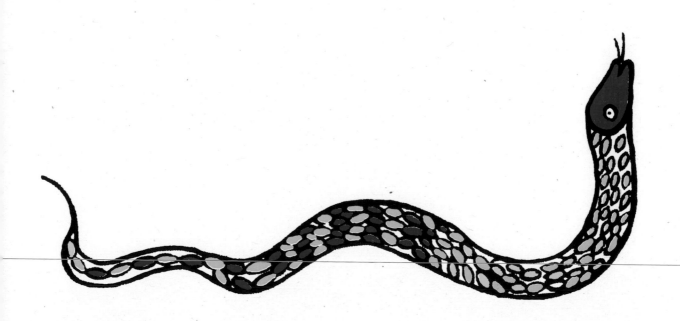

SNAKE

MADHUBANI

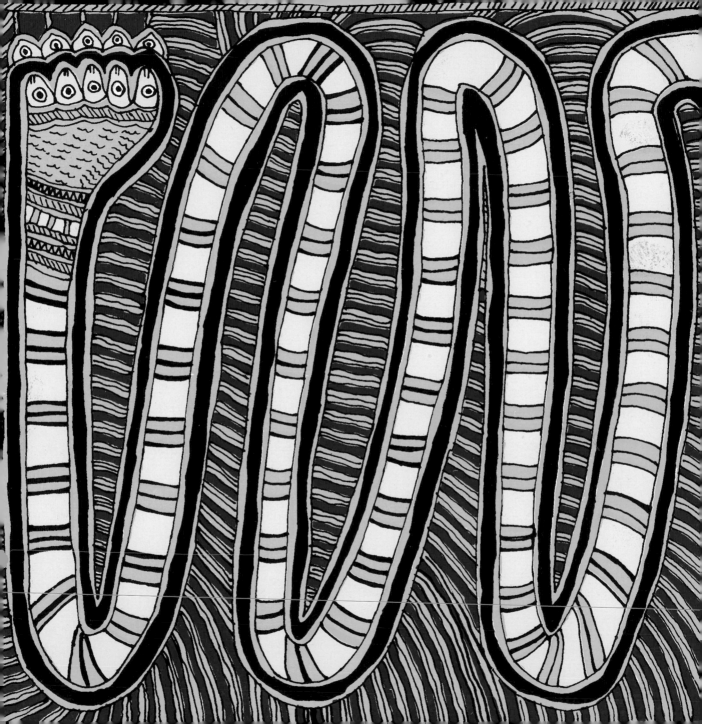

BULLS

GOND

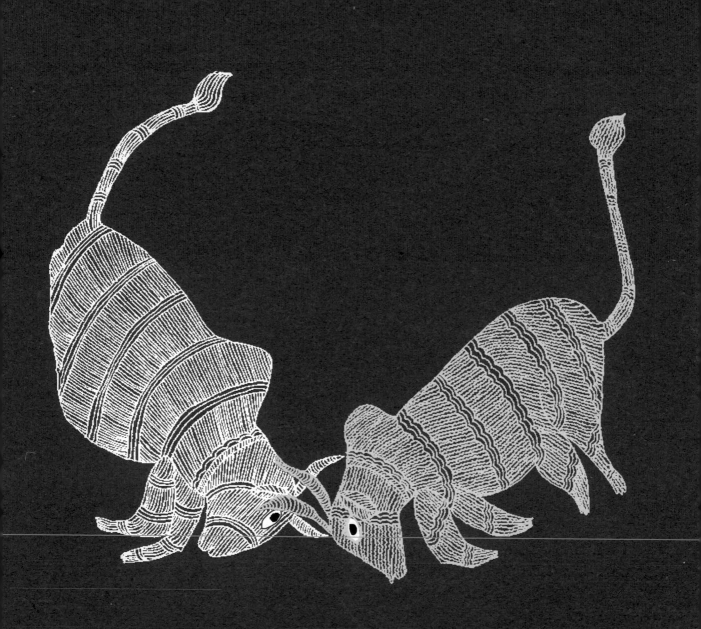

BULLS

GOND

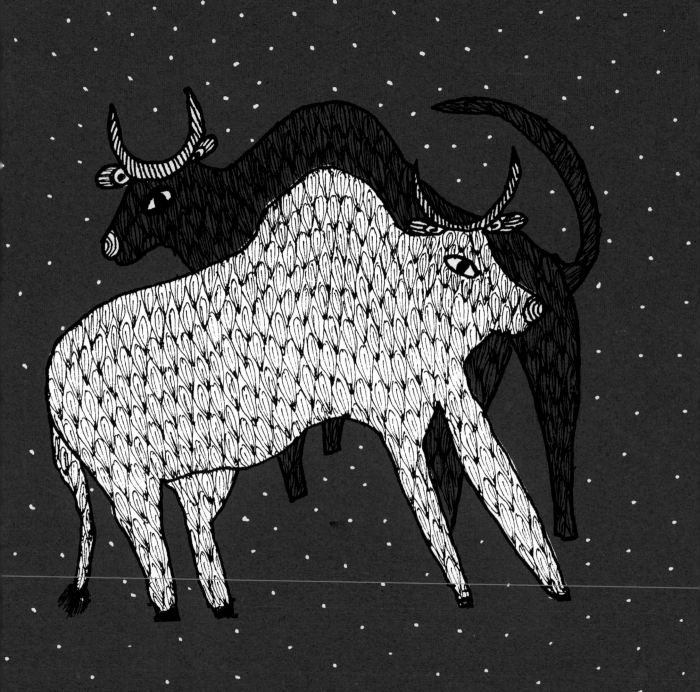

WILD BOAR

GOND

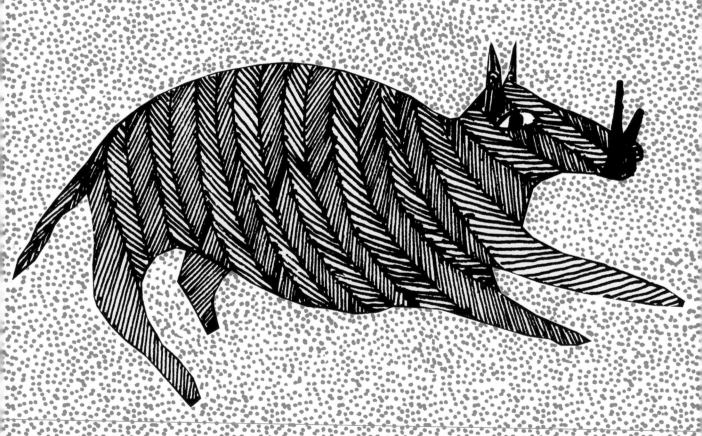

WILD BOAR

TANJORE

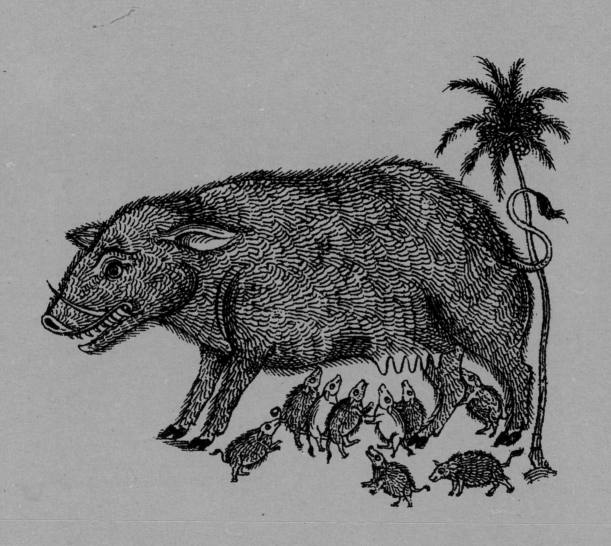

BUFFALO

GOND

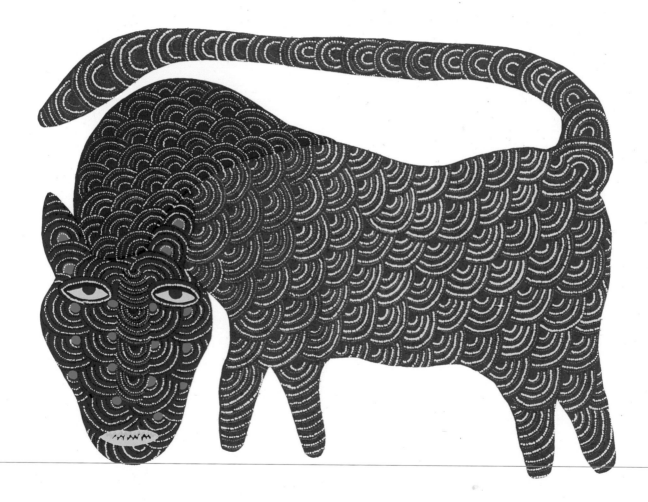

CROCODILES
GOND

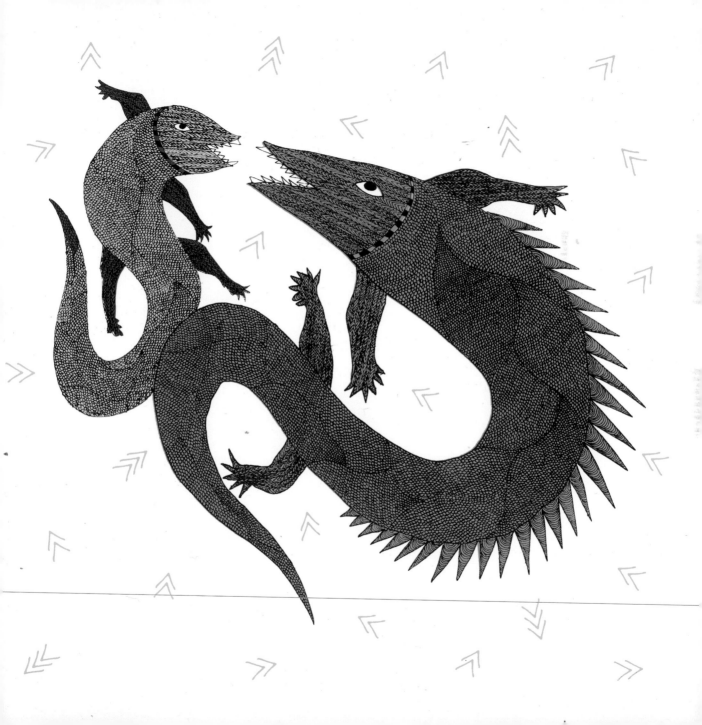

MONKEY

PITHORA

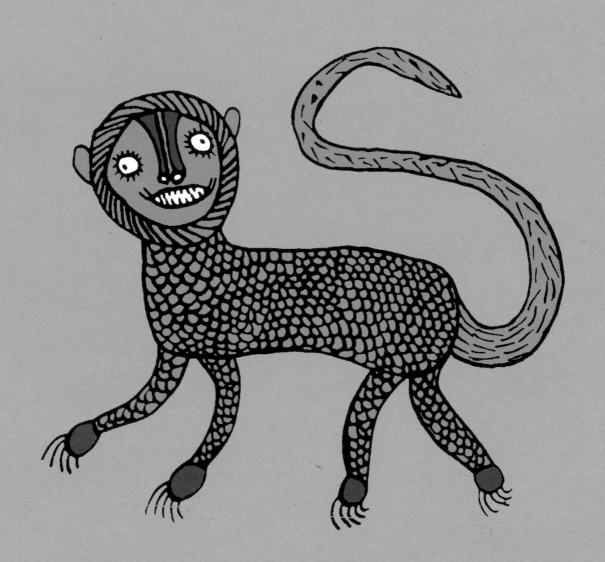

ELEPHANT

MADHUBANI

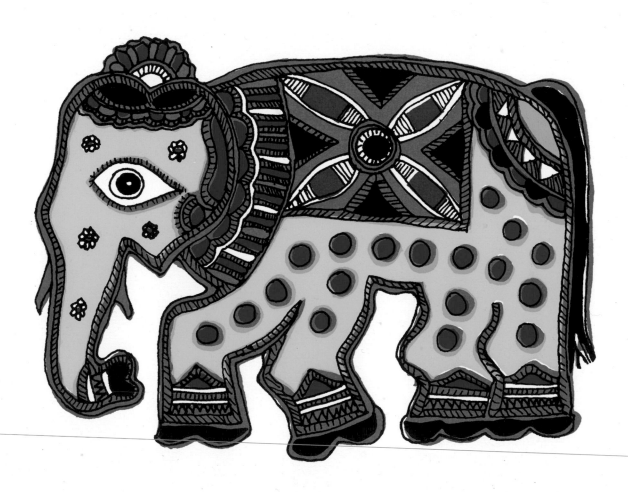

ELEPHANT

KALAMKARI

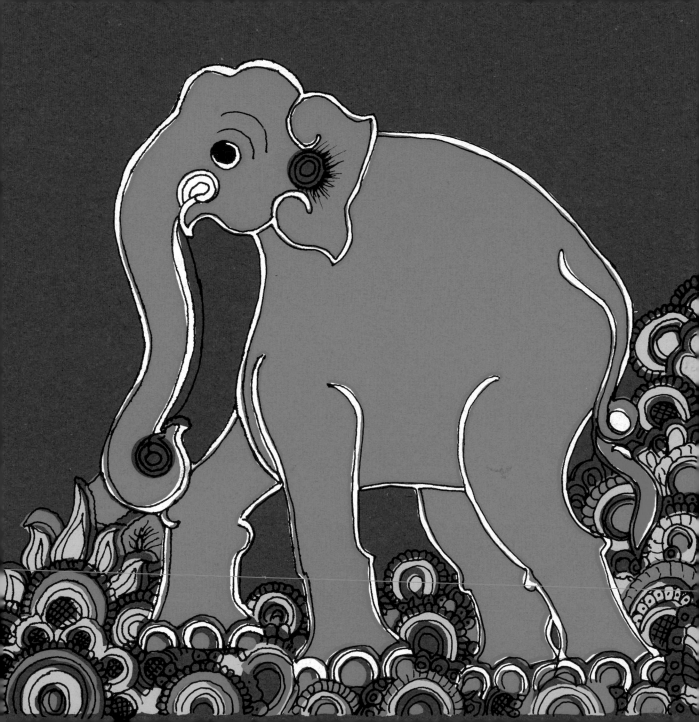

DOGS

MEENA

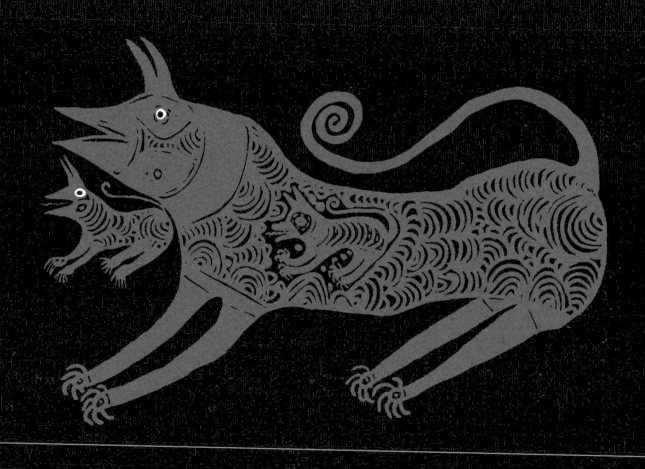

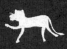

Tiger

ART STYLE: Pithora Tribal
AREA: Rajasthan/Gujarat

ARTIST: Paresh Ratva (m)

Ritual and decorative art form, painted on walls of houses, using natural earth colours

THEMES: animist beliefs, local myths and legends

THIS PICTURE: Detail from an original painting done on cloth

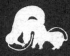

Tigers

ART STYLE: Gond Tribal / AREA: Madhya Pradesh

ARTIST: (Late) Jangarh Singh Shyam (m)

Ritual and functional art with distinctive decorative elements, painted on walls of houses, using natural colours

THEMES: Everyday life, relationships between human beings and the natural world

THIS PICTURE: Detail from an original drawing done on paper

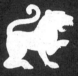

Tiger

ART STYLE: Patachitra Traditional / AREA: Orissa

ARTIST: Lingaraj Maharana (m)

Religious and ritual art, painted on treated cloth, palm leaves or special paper, using natural earth colours

THEMES: Hindu myths and legends

THIS PICTURE: Detail from an original painting done on cloth

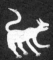

Tiger

ART STYLE: Sohrai Tribal / AREA: Jharkhand

ARTIST: Putli Ganju (f)

Similar to cave paintings, but painted on walls of houses using earth colours

THEMES: Plants, birds, animals

THIS PICTURE: Detail from an original painting done on handmade paper

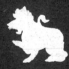

Lion

ART STYLE: Patachitra Traditional / AREA: Orissa

ARTIST: Lingaraj Maharana (m)

Religious and ritual art, painted on treated cloth, palm leaves or special paper, using natural earth colours

THEMES: Hindu myths and legends

THIS PICTURE: detail from an original painting done on cloth

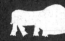

Lion

ART STYLE: Madhubani Folk / AREA: Bihar

ARTIST: Mudrika Devi (f)

Religious and decorative art, painted on walls of houses, paper and cloth, using vegetable colours

THEMES: Hindu mythology, esoteric spiritual symbols, natural scenes

THIS PICTURE: Detail from an original painting done on paper

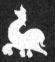

Deer

ART STYLE: Kalamkari Traditional
AREA: Andhra Pradesh

ARTIST: T. Mohan (m)

Decorative art, floral and vegetable motifs, painted or dyed on cotton fabric, using sharp bamboo sticks padded with hair or cotton

THEMES: Hindu mythology, animals and plants

THIS PICTURE: Detail from an original painting done on paper

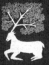

Deer

ART STYLE: Gond Tribal / AREA: Madhya Pradesh

ARTIST: Bhajju Shyam (m)

Ritual and functional art with distinctive decorative elements, painted on walls of houses, using natural colours

THEMES: Everyday life, relationships between human beings and the natural world

THIS PICTURE: Detail from an original drawing done with pen and ink on paper

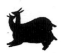

Deer

ART STYLE: Gond Tribal / AREA: Madhya Pradesh

ARTIST: (Late) Jangarh Singh Shyam (m)

Ritual and functional art with distinctive decorative elements, painted on walls of houses, using natural colours

THEMES: Everyday life, relationships between human beings and the natural world

THIS PICTURE: Detail from an original drawing done on paper

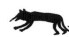

Ant-eater

ART STYLE: Pithora Tribal

AREA: Rajasthan / Gujarat

ARTIST: Chelia Hamir (m)

Ritual and decorative art form, painted on walls of houses, using natural colours

THEMES: animist beliefs, local myths and legends

THIS PICTURE: Detail from an original painting done on paper

Snake

ART STYLE: Sohrai Tribal / AREA: Jharkhand

ARTIST: Putli Ganju (f)

Similar to cave paintings, but painted on walls of houses using earth colours

THEMES: Plants, birds, animals

THIS PICTURE: Detail from an original painting done on handmade paper

Snake

ART STYLE: Madhubani Folk / AREA: Bihar

ARTIST: Mudrika Devi (f)

Religious and decorative art, painted on walls of houses, paper and cloth, using vegetable colours

THEMES: Hindu mythology, esoteric spiritual symbols, naturals scenes

THIS PICTURE: Detail from an original painting done on paper

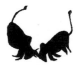

Bulls

ART STYLE: Gond Tribal / AREA: Madhya Pradesh

ARTIST: Durga Bai (f)

Ritual and functional art with distinctive decorative elements, painted on walls of houses, using natural colours

THEMES: Everyday life, relationships between human beings and the natural world

THIS PICTURE: Detail from an original drawing done with pen and ink on paper

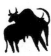

Bulls

ART STYLE: Gond Tribal / AREA: Madhya Pradesh

ARTIST: Ramsingh Urveti (m)

Ritual and functional art with distinctive decorative elements, painted on walls of houses, using natural colours

THEMES: Everyday life, relationships between human beings and the natural world

THIS PICTURE: Detail from an original drawing done with pen and ink on paper

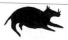

Wild Boar

ART STYLE: Gond Tribal / AREA: Madhya Pradesh

ARTIST: Ramsingh Urveti (m)

Ritual and functional art with distinctive decorative elements, painted on walls of houses, using natural colours

THEMES: Everyday life, relationships between human beings and the natural world

THIS PICTURE: Detail from an original drawing done with pen and ink on paper

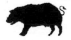

Wild Boar

ART STYLE: Tanjore Traditional/ AREA: Tamil Nadu

ARTIST: Unknown

Illustrative art, developed in the Mahrata court in Southern India, combines temple mural style with Mughal miniature art

THEMES: Hindu mythology, scenes from court life

THIS PICTURE: Detail from an original illustration for a book

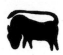

Buffalo

ART STYLE: Gond Tribal / AREA: Madhya Pradesh

ARTIST: Nandkusiya Shyam (f)

Ritual and functional art with distinctive decorative elements, painted on walls of houses, using natural colours

THEMES: Everyday life, the relationships between human beings and the natural world

THIS PICTURE: Detail from an original painting done with fabric paint on paper

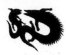

Crocodiles

ART STYLE: Gond Tribal / AREA: Madhya Pradesh

ARTIST: Mansingh Vyam (m)

Ritual and functional art with distinctive decorative elements, painted on walls of houses, using natural colours

THEMES: Everyday life, relationships between human beings and the natural world

THIS PICTURE: Detail from an original drawing done with pen and ink on paper

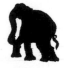

Monkey

ART STYLE: Pithora Tribal
AREA: Rajasthan / Gujarat

ARTIST: Chelia Hamir (m)

Ritual and decorative art form, painted on walls of houses, using natural colours

THEMES: animist beliefs, local myths and legends

THIS PICTURE: Detail from an original painting done on paper

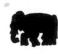

Elephant

ART STYLE: Madhubani Folk / AREA: Bihar

ARTIST: Mudrika Devi (f)

Religious and decorative art, painted on walls of houses, paper and cloth, using vegetable colours

THEMES: Hindu mythology, esoteric spiritual symbols, natural scenes

THIS PICTURE: Detail from an original painting done on paper

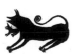

Elephant

ART STYLE: Kalamkari Traditional
AREA: Andhra Pradesh

ARTIST: T. Mohan (m)

Decorative art, floral and vegetable motifs, painted or dyed on cotton fabric, using sharp bamboo sticks padded with hair or cotton

THEMES: Hindu mythology, animals and plants

THIS PICTURE: detail from an original painting done on cloth

Dogs

ART STYLE: Meena Tribal / AREA: Rajasthan

ARTIST: Bajrangi (f) and Phula (m)

Decorative art, painted on walls and floors of houses and on objects of everyday use, using white chalk, clay and charcoal

THEMES: Animals, plants, flowers, rituals associated with marriage and festivals

THIS PICTURE: Detail from an original wall painting, reconstructed from a photograph

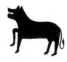

COVER
Tiger

ART STYLE: Mata-Ni-Pachedi / AREA: Gujarat

ARTIST: Jagdish Chitara (m)

Votive and ritual art, created with block prints and paintings on a special ritual cloth.

THEMES: Myths and stories around the Mother Goddess and local legends

THIS PICTURE: Detail from an original drawing done with pen and ink on paper

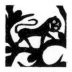

TITLE PAGE
Monkey

ART STYLE: Pithora Tribal
AREA: Rajasthan / Gujarat

ARTIST: Chelia Hamir (m)

Ritual and decorative art form, painted on walls of houses, using natural earth colours

THEMES: Animist beliefs, local myths and legends

THIS PICTURE: Detail from an original painting done on paper

Beasts of India

Copyright © 2017 Tara Books Private Limited
Editors: Kanchana Arni & Gita Wolf
Illustrations: Various artists

For this edition:
Tara Books Private Limited, India < www.tarabooks.com >
and
Tara Publishing Ltd., UK < www.tarabooks.com/uk >

First Printing 2003 | Second printing 2004 | Third printing 2007

Production Design
C. Arumugam Ragini Siruguri

Screen-printed by T.S. Manikandan, A. Neelagandan, K. Prabhu, A. Arivazhagan, T. Sakthivel,
R. Shanmugam, S. Mariyappan, A. Ramesh, M. Rajesh, S. Boopalan, S. Chinraj, N. Gandhi,
D. Ramachandran and M. Rajadurai. Bound by M. Veerasamy, Venugopal, Mohan,
M. Vinodha, M. Bhavani, V. Anbarasan, K. Ganesh and S. Muthukumaran.
At AMM Screens, Chennai, India.

ISBN: 978-93-83145-58-4

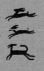

FLY LEAF
Deer

ART STYLE: Saora Tribal / AREA: Orissa
ARTIST: Karunakara Sahu (m)
Ritual art, painted on walls of houses, using
natural pigments
THEMES: Rural and familial scenes, especially
rites of passage
THIS PICTURE: Detail from an original wall
drawing reconstructed from a photograph

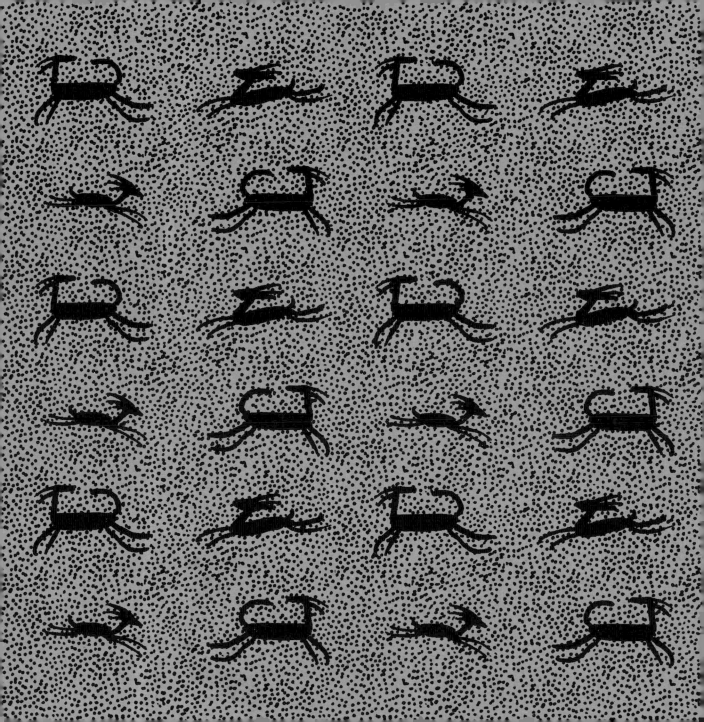